# Colourful Creatures
*Fantastic Creatures*

Zabina Nilsson

Copyright © 2016 Zabina Nilsson

All rights reserved.

ISBN: 1537280570
ISBN-13: 978-1537280578

## DEDICATION

I dedicate this book to all my family and friends who has supported me throughout my life.

You are all awesome, you lift me up.

Thank you.

## ABOUT THIS BOOK

I hope that the images in this book will provide you with many hours of joy and creativity. Each of the designs are hand drawn in Sweden, with you in mind. I do recommend that dry mediums are used, such as coloured pencils. But in case you prefer markers or sharpies, I decided to print only one design per paper, so that bleed through should not affect other images. One option is to scan and print the designs onto paper of your choice (I hear cardstock is quite popular). You are very welcome to do this and colour each design as many times as you please. However I ask you please do not share these designs for others to colour. The income I make from this book will help me through my studies and motivate me to create more designs.

I wish you the most wonderful day.
-Zabina

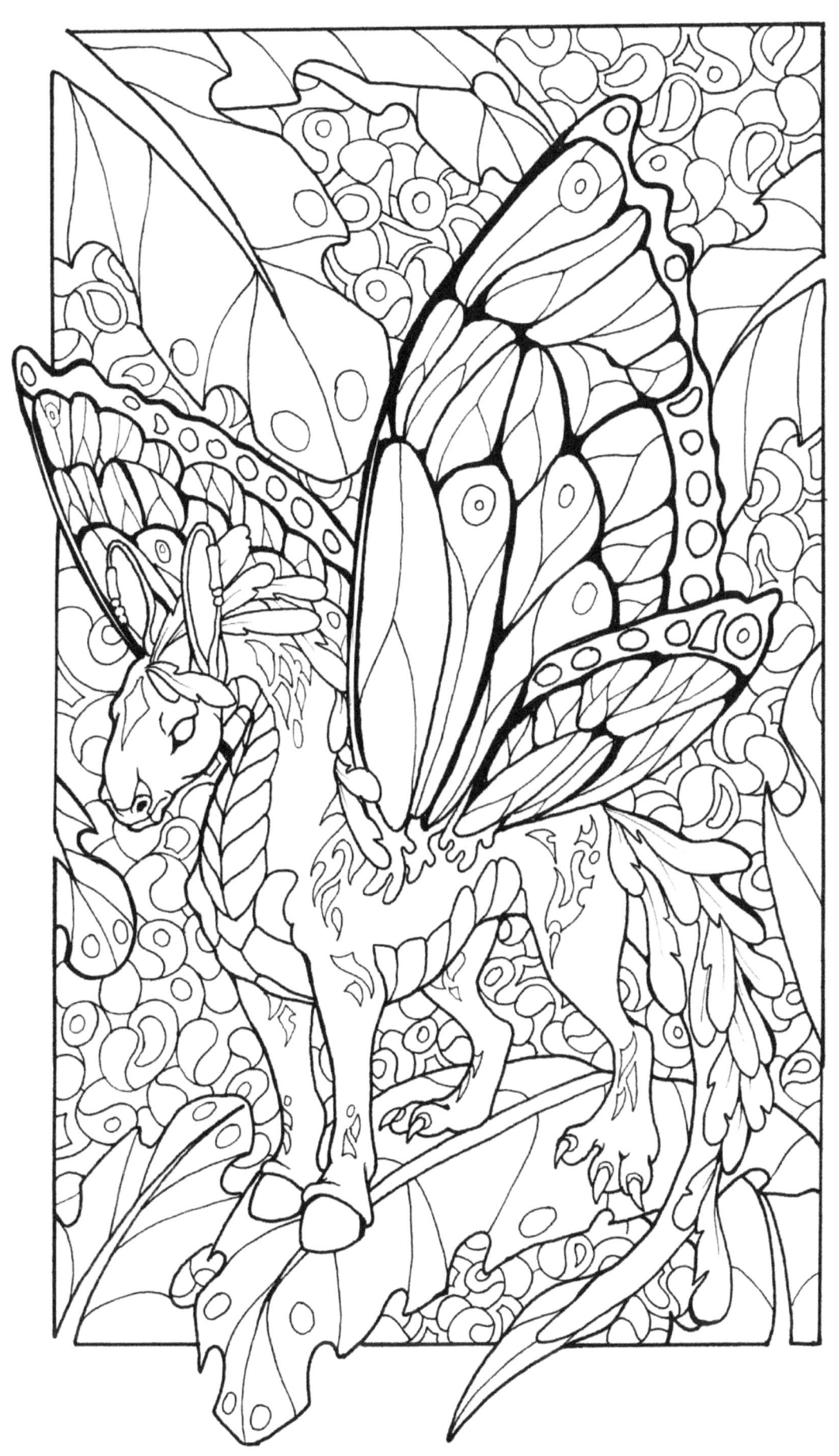

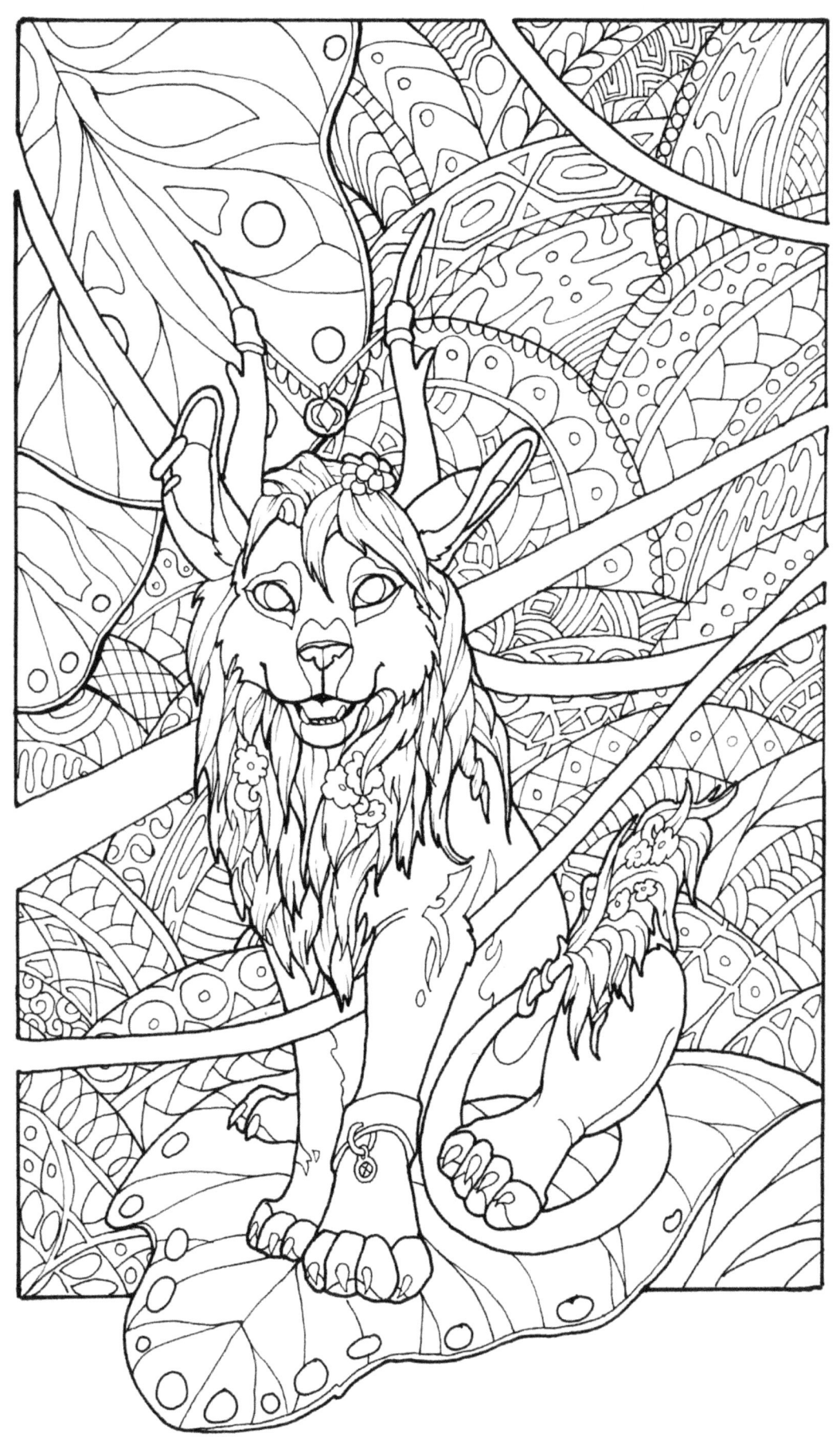

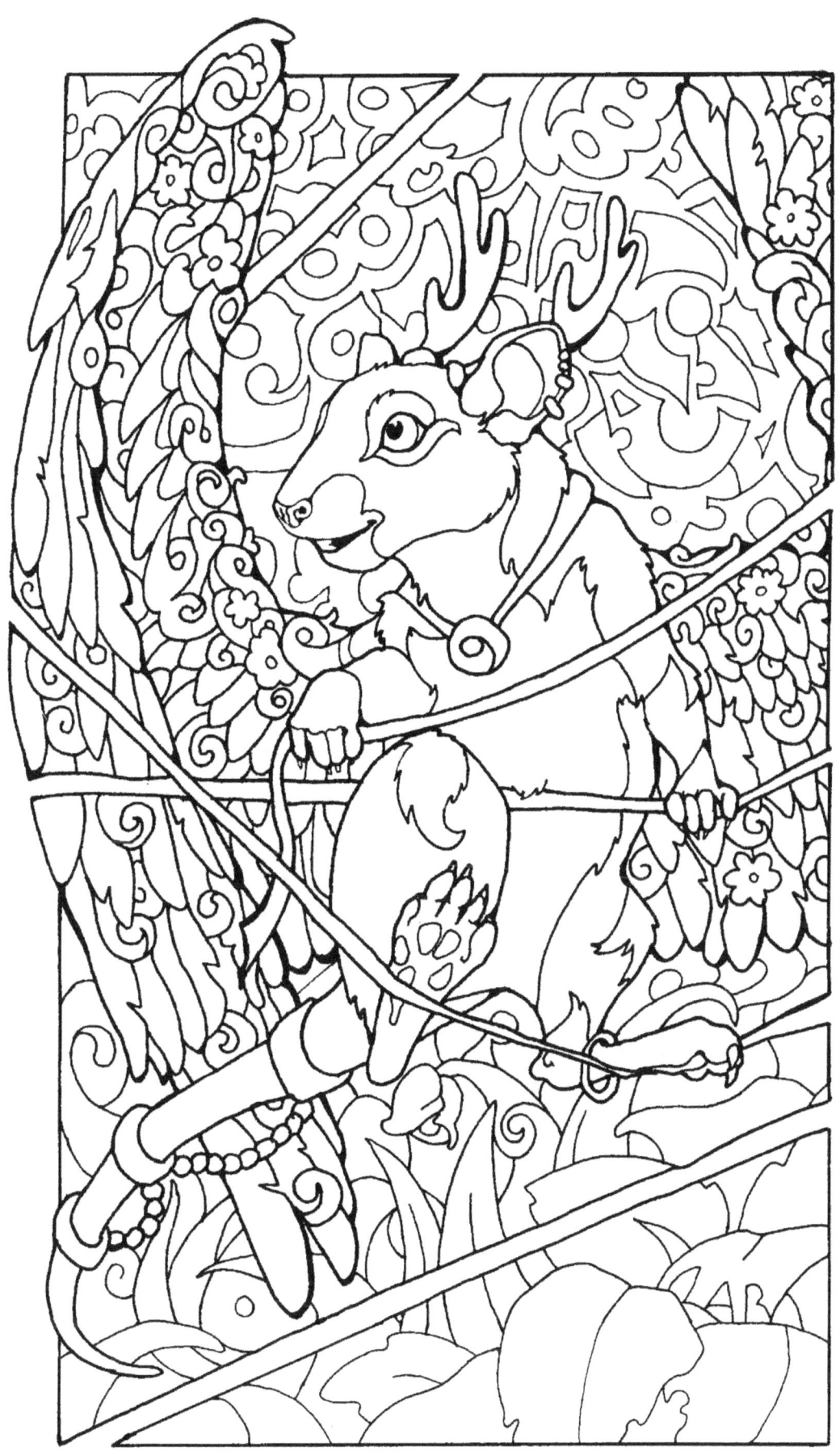

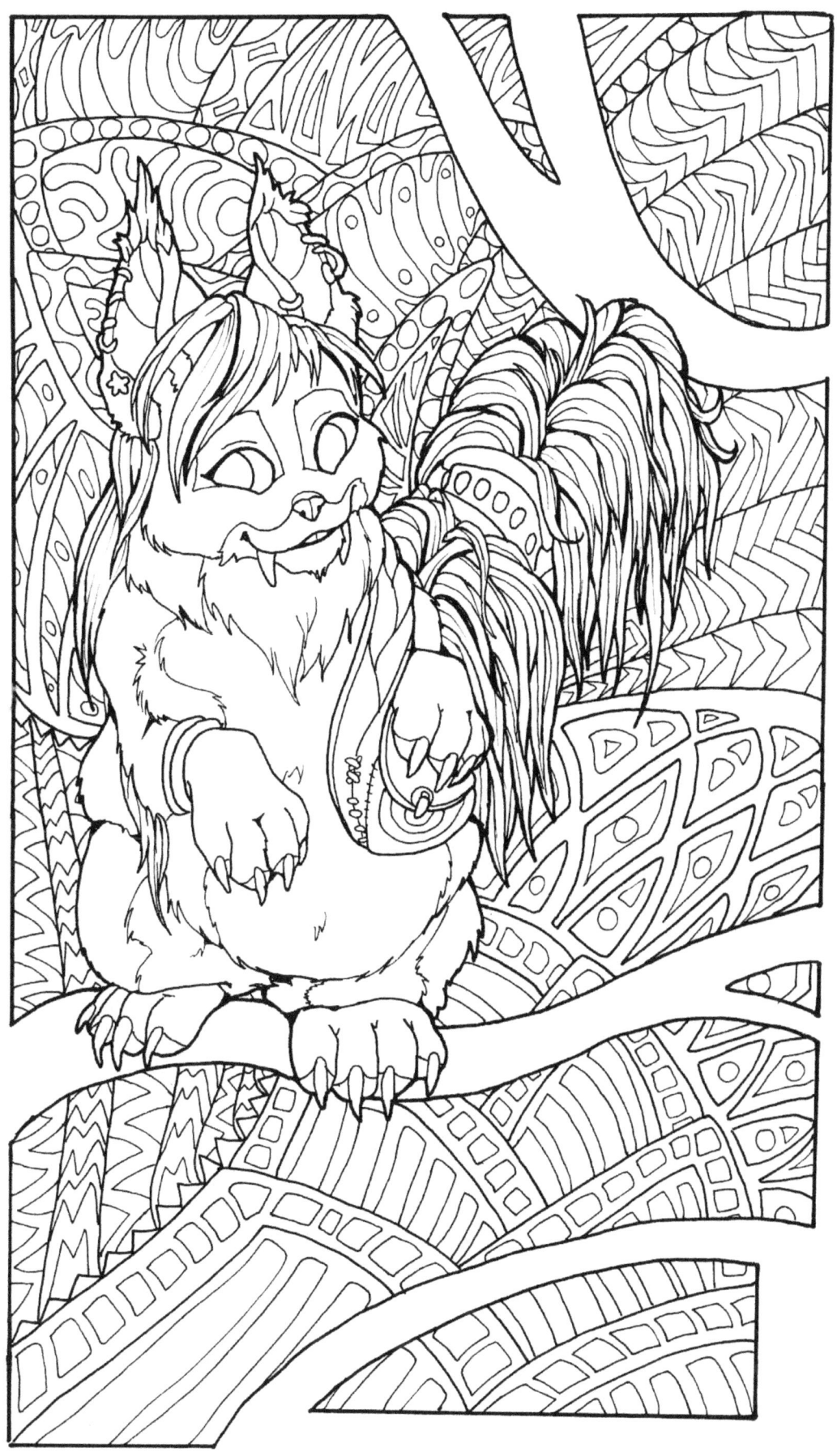

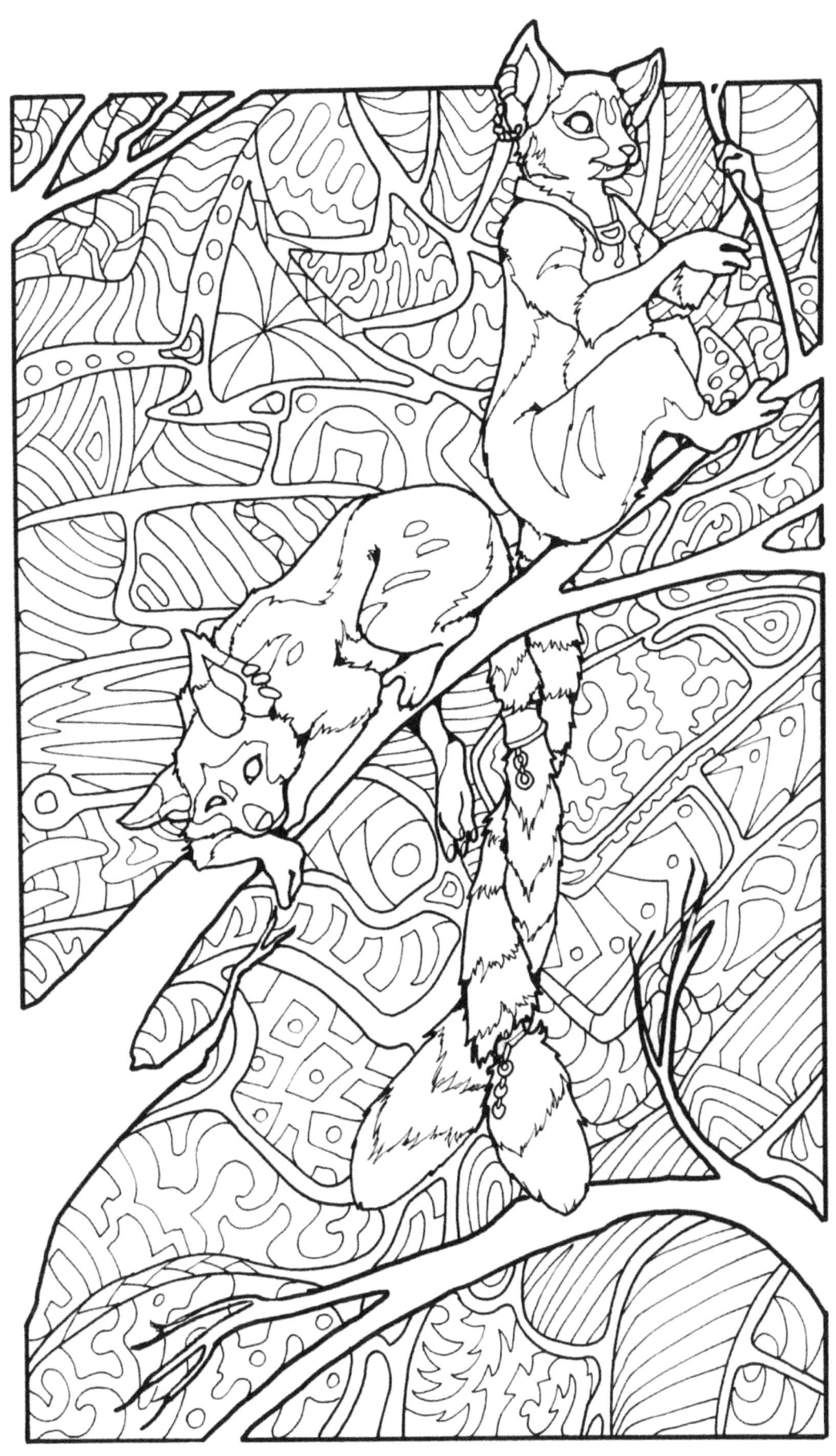

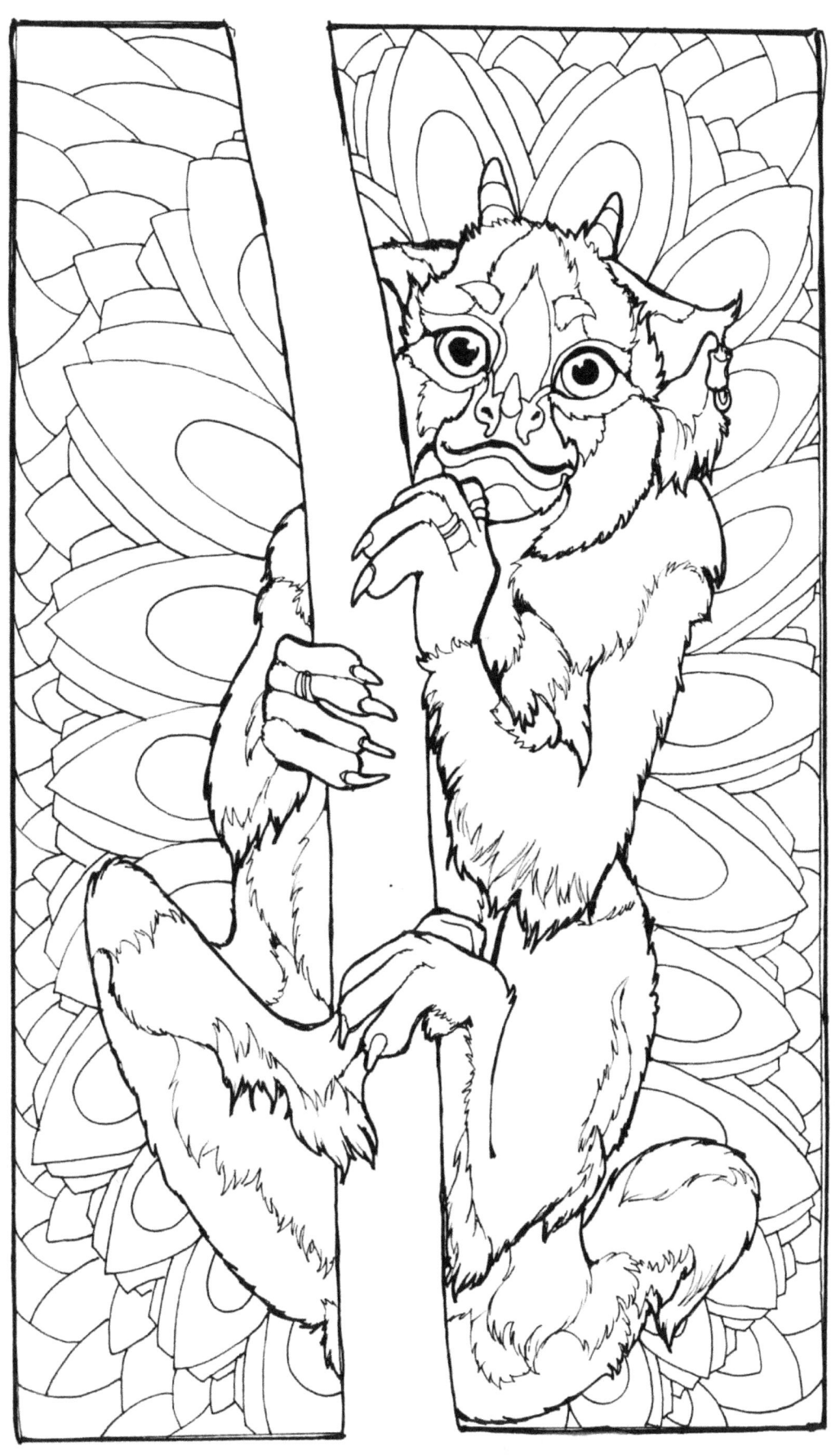

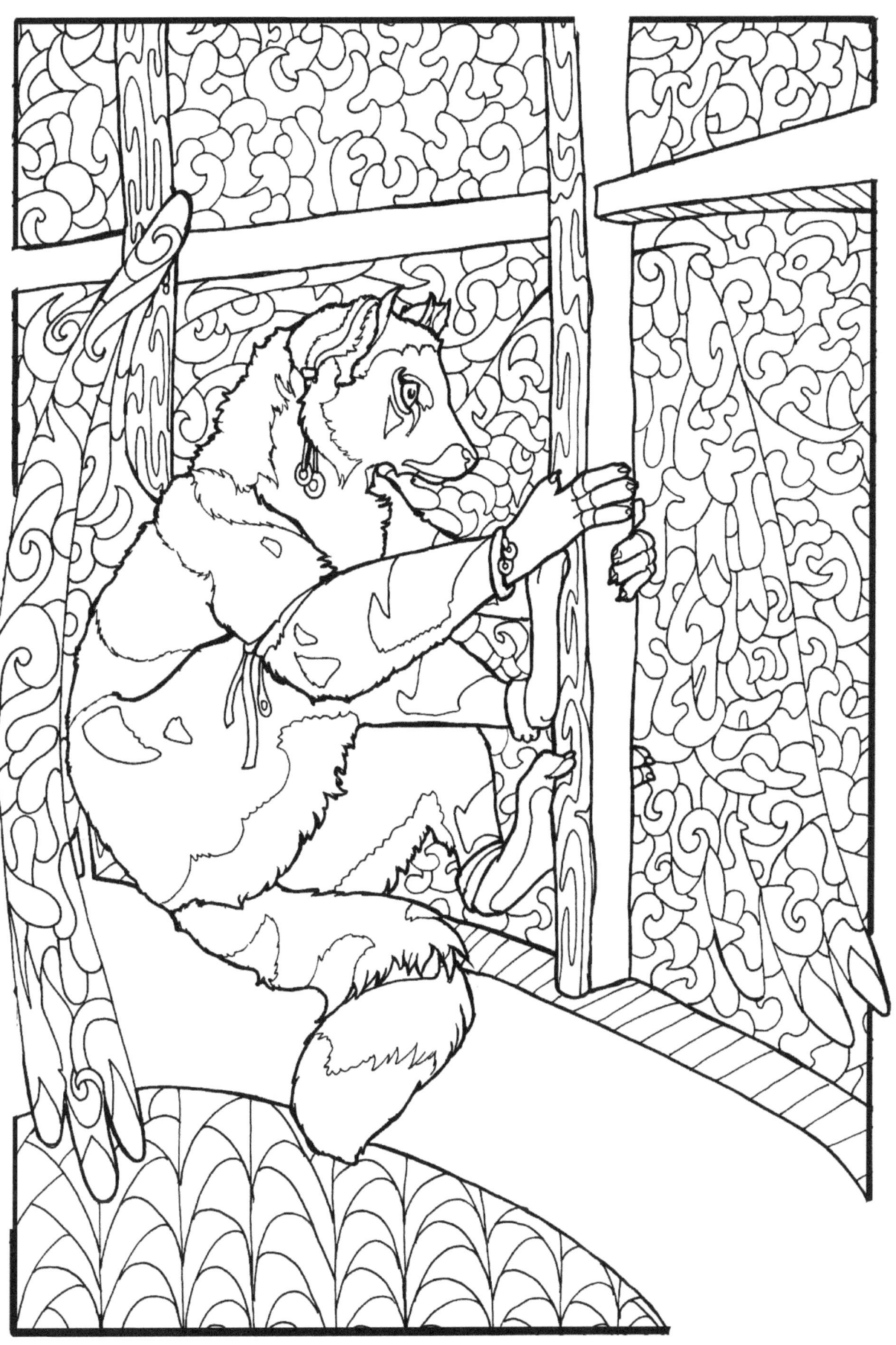

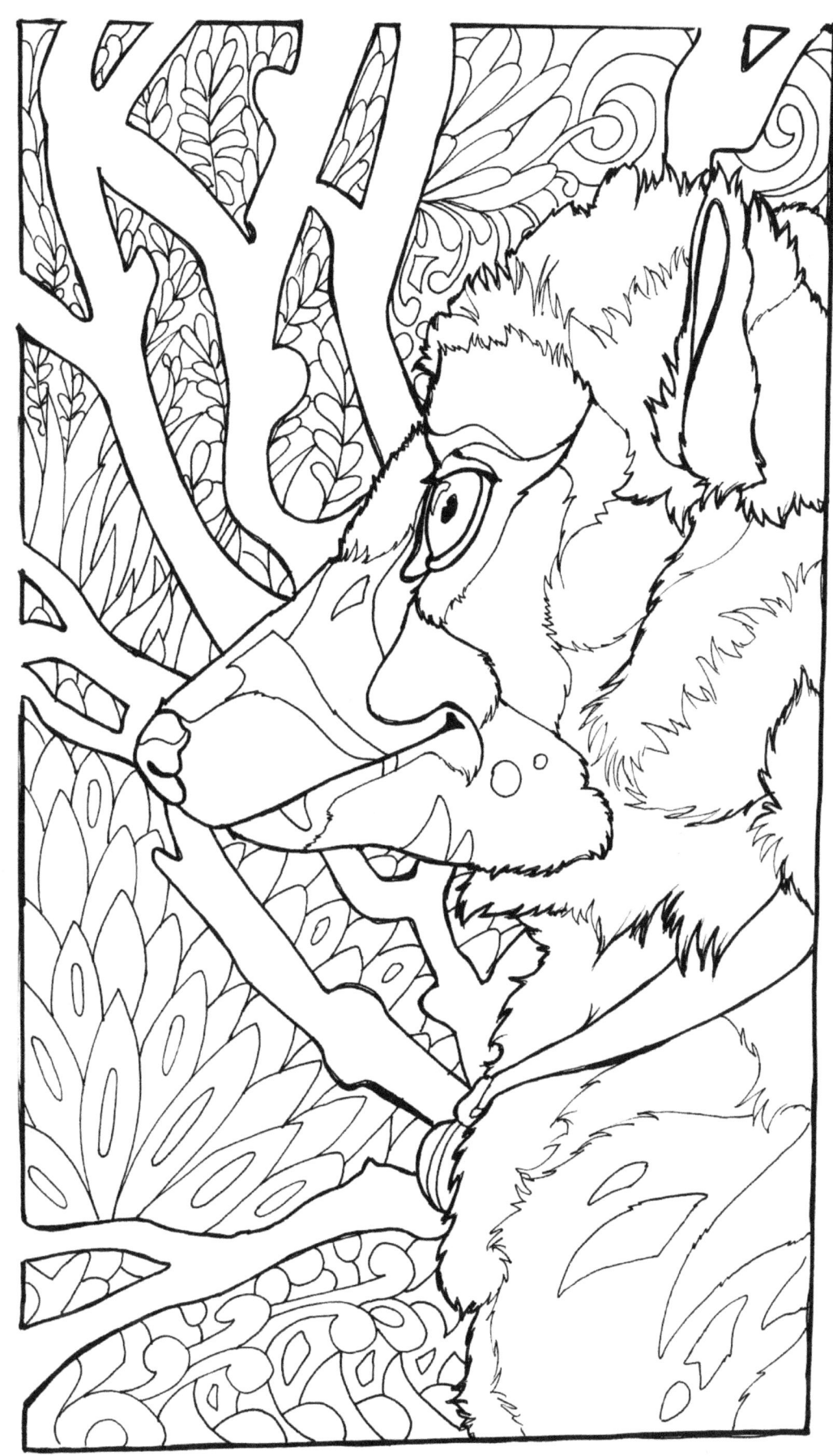

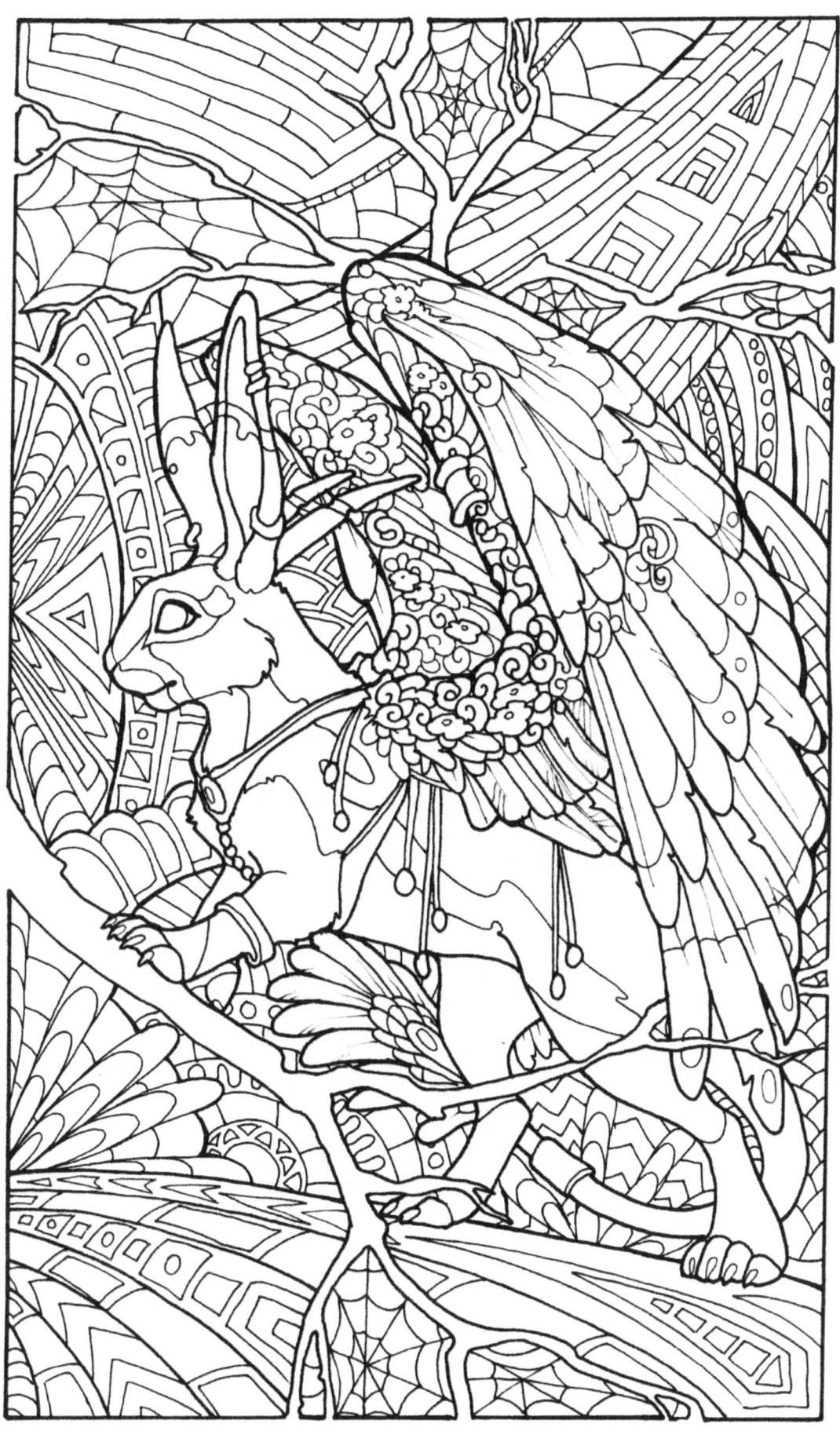

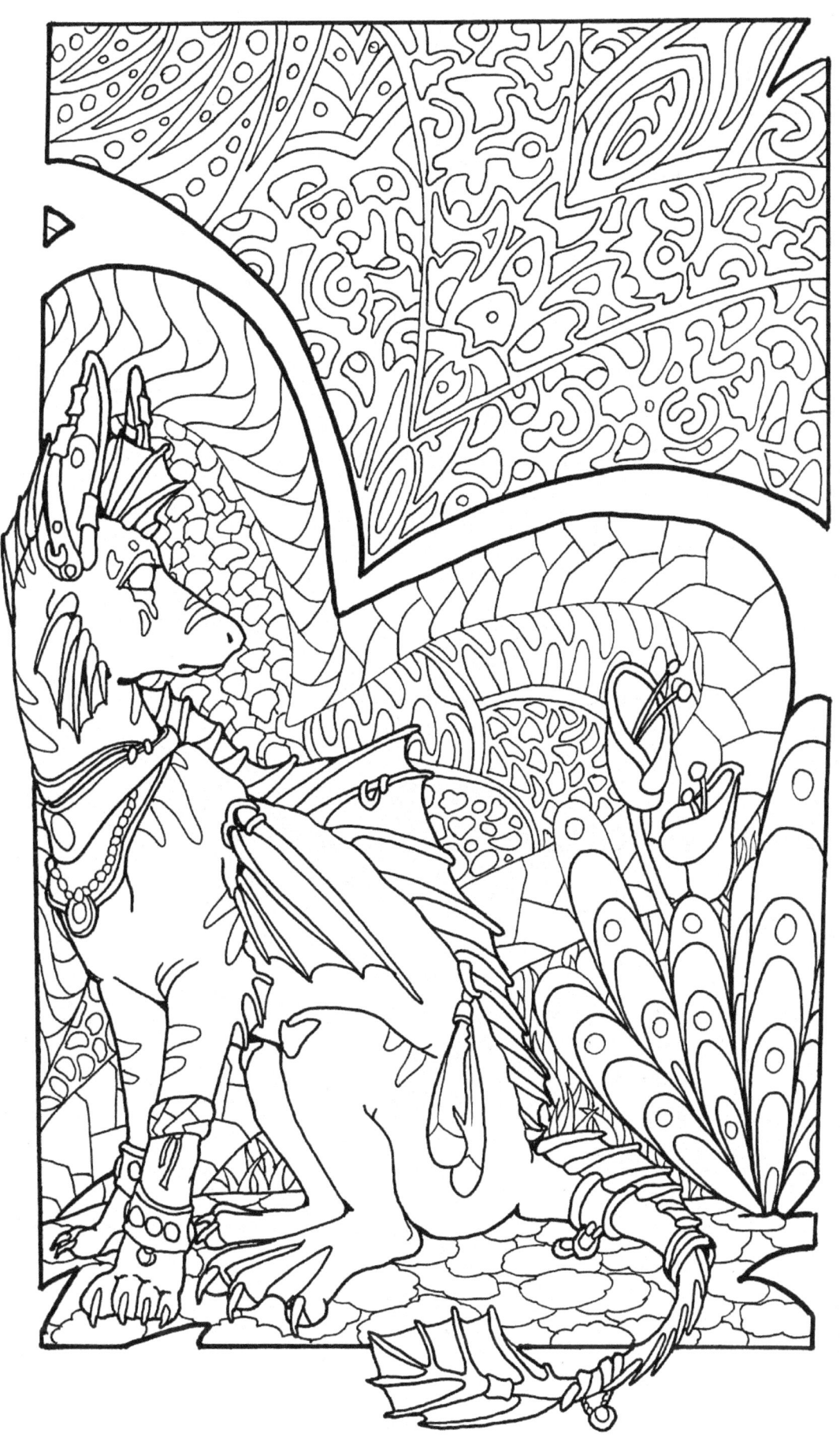

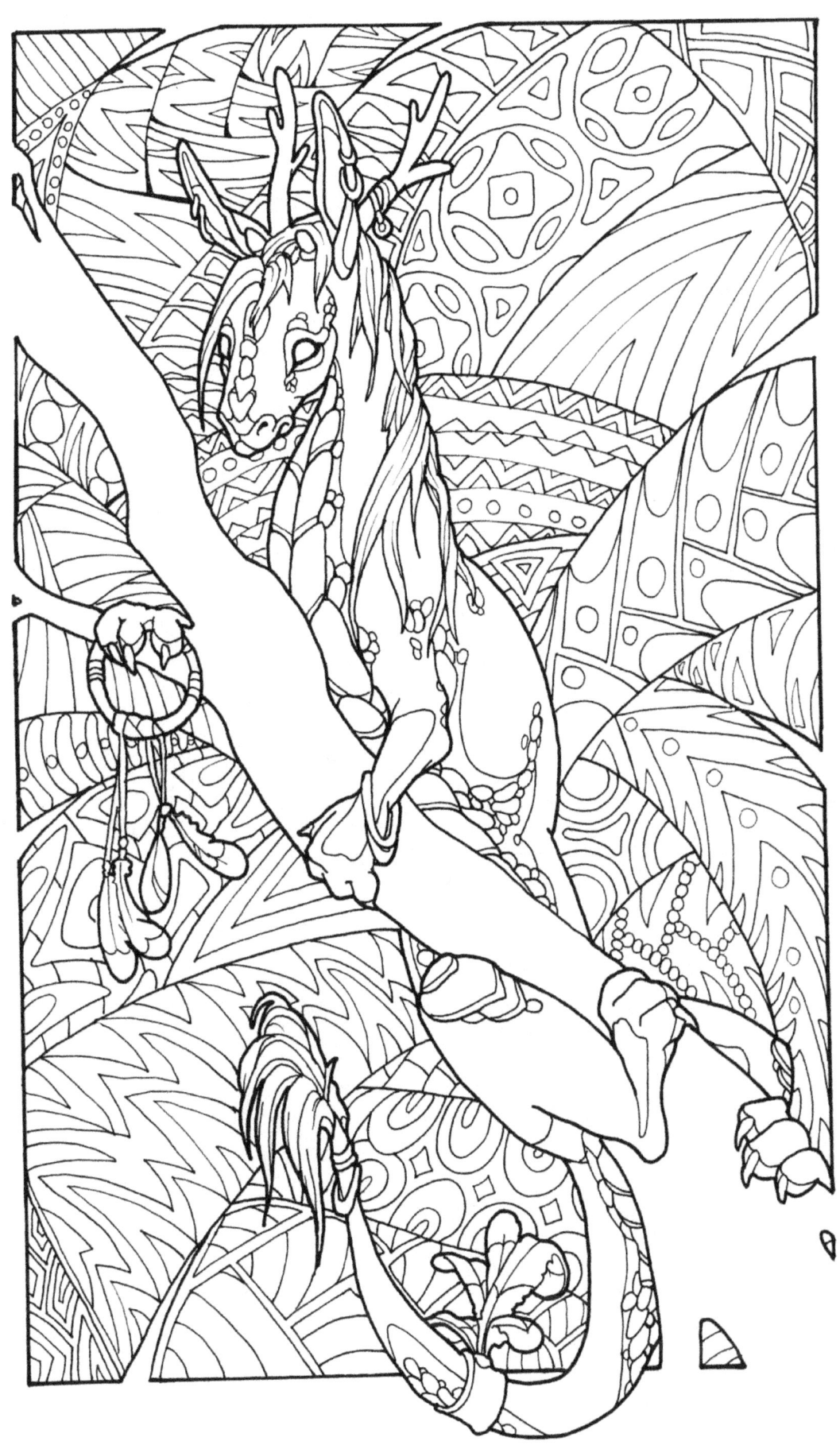

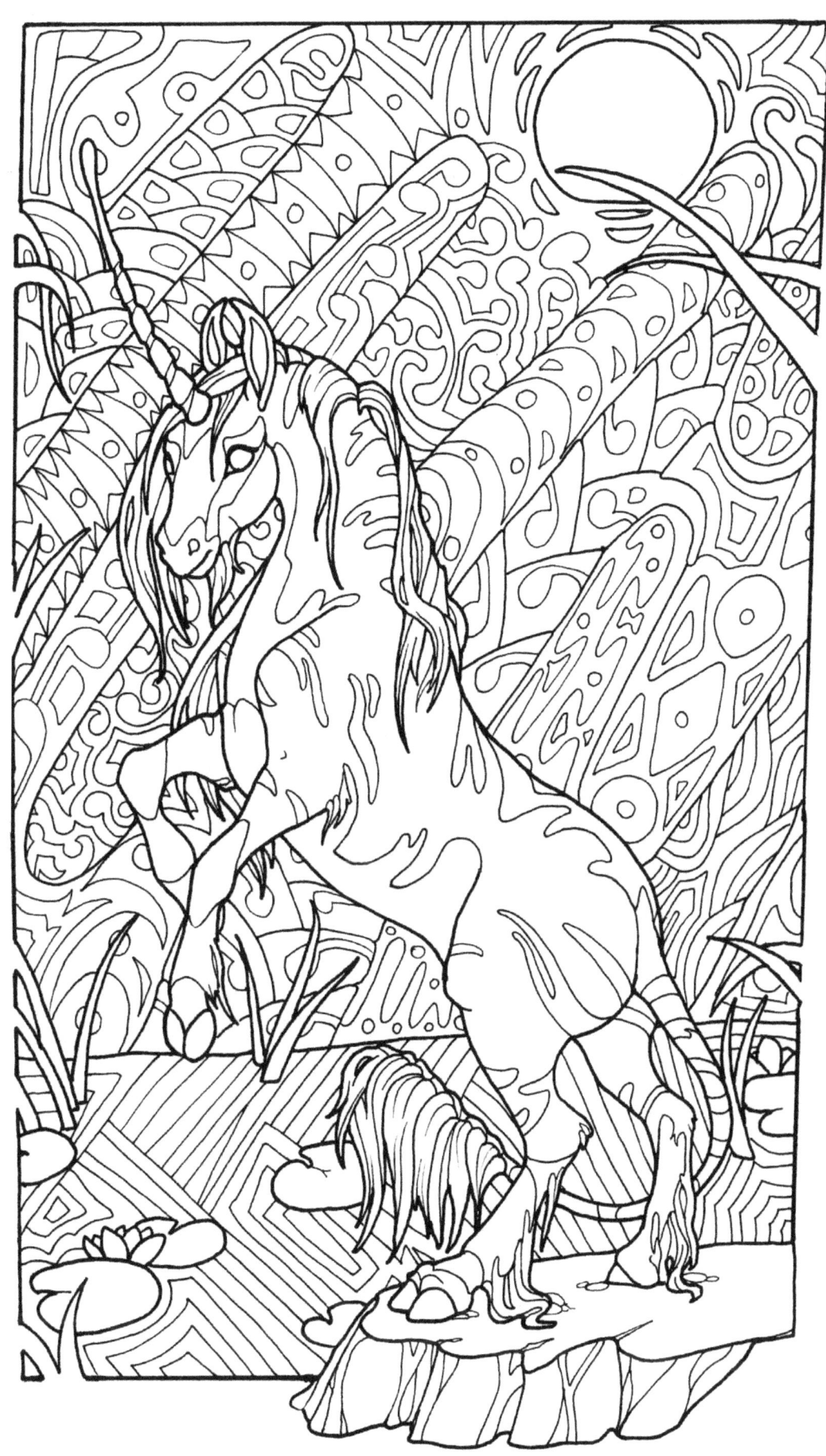

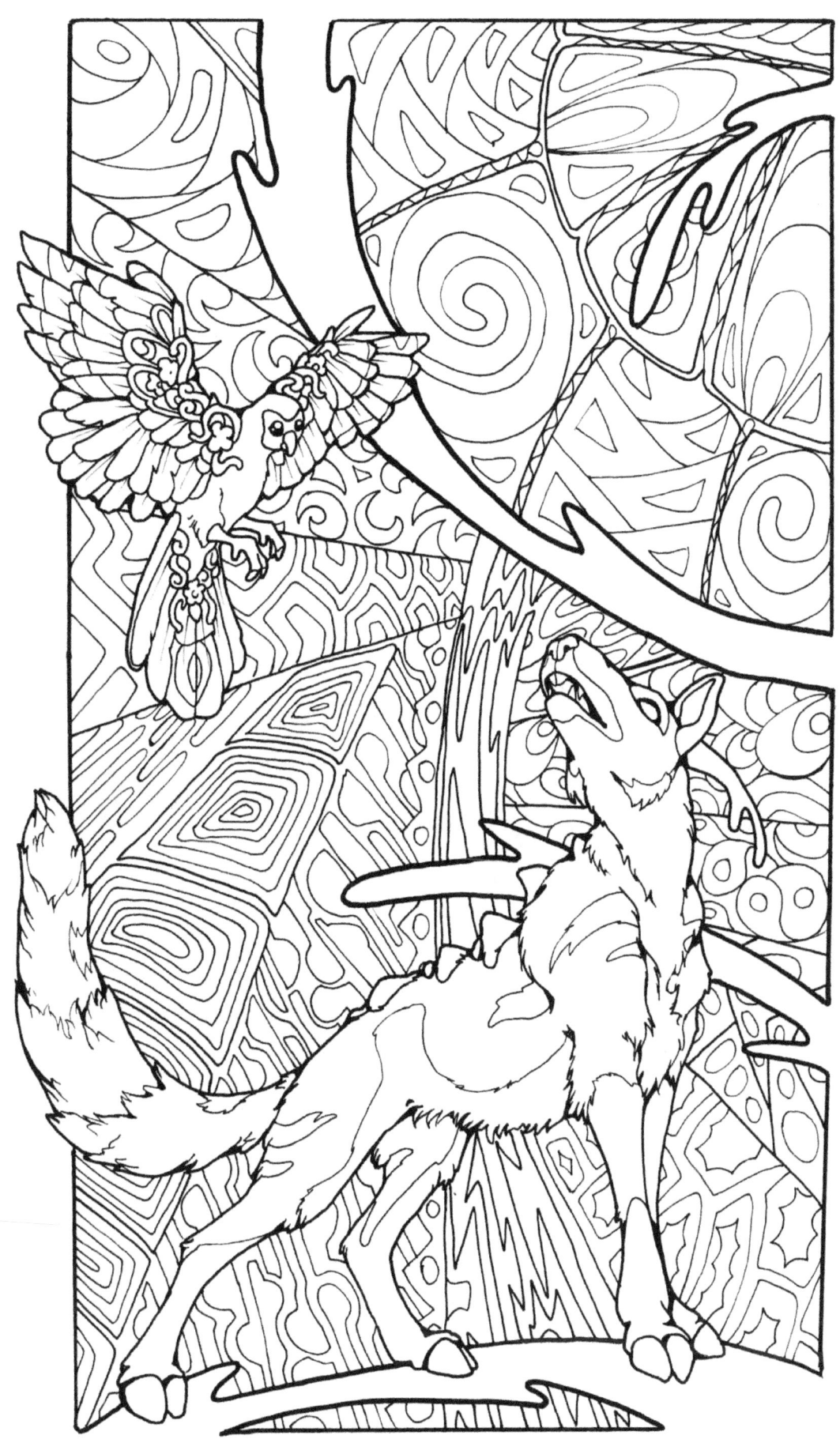